D0033090

Ten Minutes to the Speech

Your last-minute guide and checklist for speaking in public

by
Vance Van Petten

DISCARDED

YUMA COUNTY
LIBRARY DISTRICT

www.yumalibrary.org

Other books in the
10 Minutes 2 Success series:

Ten Minutes to the Audition
 by Janice Lynde

Ten Minutes to the Pitch
 by Chris Abbott

For more information, visit:
www.Tallfellow.com

Copyright © 2007 by Vance Van Petten

All rights reserved. No part of this publication may be reproduced, stored in a retrieval system or transmitted in any form or by any means: electronic, mechanical, photocopying, recording or in any fashion whatsoever, without the prior written permission of the Publisher.

Published by
Tallfellow® Press, Inc.
1180 S. Beverly Drive
Los Angeles, CA 90035
www.Tallfellow.com
ISBN: 978-1-931290-59-3
Printed in USA
10 9 8 7 6 5 4 3 2 1

JUL 2 9 2008

Dedication

To my loving wife, Stacy, and our children: Robert, Vanessa, Courtney and Haley. Without them, I would be speechless.

Acknowledgements

Writing a book is not like writing a speech. The latter can be done solo. To write a book, you really must rely on many resources.

First and foremost, my gratitude must be extended to the person who initially motivated me to put down in writing what I had been practicing for years. Leonard Stern heard me speak on a few occasions and he was kind enough to suggest that I write about public speaking. But Leonard went further: He introduced me to his partner, Larry Sloan, and the Tallfellow staff—Laura Stern, Claudia Sloan—and to my very patient editor, Bob Lovka. I am indebted to all for their support and to Bob for his hours of work in editing my initial "tome" into this user-friendly format.

Additionally, there were a few people who made some important contributions:

To Harry Attridge, Dean of the Yale School of Divinity, for his Latin phrase *"captatio benevolentiae,"* which uniquely describes the ultimate goal of every speaker: To capture the goodwill of the audience.

To Michael Boylan, organizational theorist, who strongly reinforced my ideas about the importance of personal introductions and how video clips can be used to instantly enhance a speaker's credibility.

To Lon Sobel, publisher of the *Entertainment Law Reporter*, and an excellent public speaker whom I not only admire, but whose enthusiasm I strive to emulate.

And, to John Huncke, my friend, colleague (and tennis pro-wannabe), who provided numerous references and constant support.

Introduction

"There are few wild beasts more to be dreaded than a talking man having nothing to say."

—Jonathan Swift

On the list of what people most fear, public speaking comes right before death. At a funeral, some people would rather be in the coffin than give the eulogy. The purpose of this book, at the very least, is to reverse that order of preference.

Giving a speech does NOT have to be painful, frightening or even long. With the help of a few tools provided in this short book and a bit of preparation, you'll see that public speaking can not only be beneficial to your career, but will help you in any social occasion.

The first question you must be able to accurately answer is: *What is the purpose of giving your speech?* This is not just the first question but it is also the most important question to ask when preparing to speak. Your answer will help you organize the content of your speech, as well as deliver it so it will be best received and accepted by your audience.

For virtually any speech you plan to give, your purpose or goal will fit into one of these four categories:

1. Persuade the audience to take some action

2. Inform the audience

3. Impress or convince the audience

4. Entertain the audience

And yes, a good speech should have a little of each of the four, but you need to decide which one of those is your primary purpose for giving it. How you organize your speech depends very much on your goal in delivering it. Once you are clear on the goal, this book gives you all the tools you need to achieve it.

"Speech is power: speech is to persuade, to convert, to compel. It is to bring another out of his bad sense into your good sense."

—Ralph Waldo Emerson

How To Use This Book

A Guide to the Contents

SECTION 1: *The Checklist*
The 10-Minutes-2-Success checklist provides a quick and easy listing of 16 points to consider before giving your speech. The checklist will provide you with practical advice, proven verbal tools and helpful hints that will make your speaking engagement a success.

SECTION 2: *The Chapters*
Section 2 is a detailed and concise explanation of the checklist points. This section describes various ways you can improve your speech and offers helpful and humorous examples that illustrate how you can be an effective public speaker.

SECTION 3: *Prep Work in the Days Before the Speech*
If you've been lucky enough to find this book a few days before you have to deliver the speech, here are all the tools you need to prepare and write a successful presentation. Starting from scratch, this section explains ways to organize your speech so that your listeners will feel connected with you and

will take home your message. Section 3 also examines how best to use charts, props and visual aids and offers helpful hints in handling unnerving situations.

SECTION 4: *References and Books for Further Reading*
Section 4 provides useful references to other authors who have written about various issues relating to public speaking.

"A good speech, like a woman's skirt, should be long enough to cover the subject and short enough to create interest."

—Winston Churchill

Checklist

1. Take Everything You Need

Make sure you have everything you'll need to give your speech (directions, handouts, props, your written notes, etc.) Page 21

2. Are We There Yet?

You can't make a favorable impression on your audience if you don't get to your audience! Double- and triple-check your directions. And, just in case you encounter traffic or other problems getting to your destination, it is essential that you arrive EARLY Page 23

3. Check the Venue and Check the Equipment

In order to have the best possible impact on your audience, you need to know about the venue. Is the room large, well-lit, and set up with a podium? How noisy is the room and will you be required to read from a teleprompter? Page 25

4. Touch Base with Your Moderator or the Person Introducing You

The moderator is the first person the audience

will look to for their opinion of YOU! So, you need to find out from the moderator such pertinent information as where you are on the agenda and how you will be introduced

5. Know Your Audience

If you haven't previously been given any information about the makeup of your audience, get some info now about its size, needs and demographics. The more you know about your audience ahead of time, the more you will be successful in communicating effectively

6. Check Your Appearance!

Make sure you have time to check your clothes, hair, zippers, pocket change, jewelry, etc., BEFORE you go onstage.

7. Smeathing

The best way to prep yourself before speaking is to "SMile while deeply brEATHING." It is the most effective way to relax yourself while starting to get the audience to like you

8. Say "No!" to Stage Fright

There are seven proven tools that will help you conquer your stage fright: Remember that the audience is on your side; think positively; maybe even think silly thoughts; focus on certain people you know in the audience; concentrate on clarity; use relaxing techniques; or simply confront your fears

9. Turn Up Your Enthusiasm!

Enthusiasm is essential to good public speaking and it takes two forms, being enthusiastic about your subject and being enthusiastic about your audience. And, by building enthusiasm, you are halfway to showing real charisma!. Page 51

10. For Openers...

There are nine ways to effectively begin your speech in order to immediately engage your audience and get them on your side: short personal stories, uniqueness, questions, video clips, humor, topical news, quotations, flattery and retrospectives Page 53

11. Speak with Confidence

If you speak with confidence, the audience will imbue your words with sincerity. You'll be able to avoid "credibility pitfalls" such as false logic, bogus claims, hyperbole and incomprehensible words Page 61

12. Never Apologize!

Unless you arrived late for your speech, or you are setting up a funny and relevant joke, NEVER apologize to your audience. Your goal is not to be subservient; it is to have your listeners identify with you. . . Page 63

13. Involve the Audience

Engage your audience so that they are not just passively listening. No trick is too childish if it will

enhance the physical participation of your listeners. For example, try having the audience: raise their hands, stand to be counted, applaud, hold hands or stamp their feet! Page 65

14. Handling Handouts

Never distribute "handouts" until the <u>end</u> of your speech . Page 69

15. Wrap Up Quickly and Exit Gracefully

Your conclusion should <u>very briefly</u> restate your main points and leave the audience feeling a sense of completion . Page 71

16. Now, Don't Beat Yourself Up!

Congratulate yourself for tackling one of life's most difficult tasks: SPEAKING IN PUBLIC. If you start going into self-analysis, stop! Instead, seek out a few members of the audience and ask them for their honest feedback on your speech Page 73

His speeches to an hour-glass
Do some resemblance show;
Because the longer time they run
The shallower they grow.

—Anonymous

What To Do Ten Minutes Before Your Speech... and During Your Speech

1. Take Everything You Need

Have you thought carefully about everything you'll need in order to give your speech? Obviously, you need to bring a copy of your speech, or the outline or notes you'll be relying on to give your speech. Take a few seconds to think about the other important things you should bring with you.

Do you have directions to the venue? You certainly want to have clear directions so you don't get lost, even down to the building and room locations. You also should inquire as to whether there is any special dress code at the venue where you will be speaking. As you make your inquiry, make sure to get the correct pronunciation of the name of the person who will be introducing you. And, since you will be talking with a lot of people, take some breath mints with you—not gum!

Are you distributing any handouts to your audience after your speech? Make sure to bring your charts,

graphs or other visual aids with you. If the amount of documents is burdensome, give some thought to having them delivered to the venue the morning of, or day before, your speech. And, don't forget your pointer, laser pen or other props that you may wish to use during your speech. Finally, don't forget to bring an extra supply of business cards with you to offer to interested members of the audience who may want to follow up with you.

2. Are We There Yet?

It is essential that you arrive EARLY. Don't take any chances. Start out at least ten minutes sooner than you would normally leave. Nothing is more nerve-rattling than having to rush to your destination. You might encounter traffic; you may have poor directions and have to ask for help along the way; you may have car problems. (This book is intended to help you have a positive experience while public speaking and the first positive step you can take is to make sure you know where you're going and how much time it will take to get there.)

If it looks like you are going to arrive late, don't panic. A few years ago, the National Association of Television Program Executives ("NATPE") asked me to be a speaker on an important panel at their annual convention. Their convention was being held in New Orleans that year and, despite my plans to arrive early, I encountered so many extraordinary problems getting a taxi to the venue, I was definitely going to arrive late. As I ran down the convention halls, instead of panicking, I began to think of ways that I could enter the large room without insulting the audience with my tardiness. As I entered the back of

the room, I saw that the moderator for the panel had already started and was in the middle of introducing the three other speakers on the dais. I decided to walk up the middle aisle and when she came to explaining the empty chair, I shouted from the back of the room, "Yes, the mikes are working well and I can hear you just fine."

Take my advice, you don't want to put yourself through such anxiety—plan to arrive very early.

3. Check the Venue and Check the Equipment

Know Your Room and Your Place In It. If you haven't previously checked out where you'll be speaking, do it NOW. Here is a checklist of questions to ask yourself:

Can the audience see you? Make sure to check the sight levels from different places in the room.

Can the audience hear you? Test the acoustics to make sure they can. And remember that it is much easier to hear yourself in an empty room, so adjust your thinking to how you will be heard in a crowded room.

Is there a podium? If you are uncomfortable speaking without a podium, check to see if there is one—or at least a table or microphone stand. If you have not given many speeches, a podium provides you with the most comfortable setting. You can place your notes on it and it is a safe place to put your hands. ("Safe" because if you don't yet know how to use your hands effectively while speaking, the podium will hide them from the audience.)

How is the lighting? Advise the host to turn up the lights if they are too dim; you don't want to make it easy for your audience to fall asleep.

Are there distracting noises coming from adjoining rooms? Loud noises are like having a white elephant in the room. Acknowledge what everyone is hearing or thinking and add that you have also arranged for someone with a jackhammer to let go with his noise whenever someone starts to doze off—or, if you are uncomfortable with humor, reassure them that you will do your best to talk over and around the distractions.

Are there windows in the room which will allow your audience to be distracted by passersby? If so, see if *you* can face the distractions instead.

What is the backdrop behind you? You should dress so that you don't disappear into—or contrast too sharply with—your background.

How does the room smell? Seriously, if you start your speech amidst a stale, moldy smell that permeates the room, you won't be blamed UNLESS you fail to mention it, hopefully with humor. This again gives you an opportunity to connect with your audience. If a smell is so strong that everyone is aware of it and you ignore it, you are not in sync

with your audience. Ignoring obvious distractions is not recommended. Acknowledge the white elephant in the room, then get on with your speech.

Can you read from the room's teleprompter?
Reading from a teleprompter is not like reading from a book. When you read a book, your eyes take in several words at a time, but when using a teleprompter, unless you are an accomplished speaker, you should only read one word ahead. Try it. It keeps your words from sounding choppy and it's a great way to slow your delivery down. It's also important to establish a relationship with the person running the teleprompter so that s/he knows the speed at which you'll be speaking. Try developing a code to let him or her know if you get in trouble—without having to embarrassingly say "back up!" More importantly, make sure the teleprompter isn't located so far away that you are squinting to read it. You don't want to experience what Lauren Bacall did at the 2006 Oscar® ceremony. After rehearsing her speech with her glasses on, Ms. Bacall made the mistake of deciding at the last minute that she didn't want to appear dowdy on camera. When the event was televised, she didn't look dowdy; rather, she struggled so mightily to read the teleprompter that she appeared to have had a few drinks before the party, or worse, that she was somewhat disoriented!

Benefits of a pre-speech inspection: There is a positive side to this pre-speech inspection. Try to find out if there is any special significance to the room and incorporate that interesting tidbit in your opening. It is another great way to connect with your audience and local venue. It also helps to check out the restroom locations in advance—not just for your personal use, but also in case you are asked by a member of the audience. Also, if you will be reading from a teleprompter, it is essential that you test yourself on it ahead of time.

4. Touch Base with Your Moderator or the Person Introducing You

The moderator or host who introduces you is giving the audience its first impression of you. What s/he says about you serves as the barometer for the audience. If s/he has genuine affection and respect for you, the audience will pick that up and you will start your speech with them already on your side. Before analyzing the importance of your introduction, you first need to ask the moderator a few questions.

Where Are You on the Agenda? Are you speaking right before a meal break when the audience is more impatient? Are you speaking right after lunch when everyone is feeling a bit drowsy? Are you the last person on a long agenda of speakers? Such a place can be deadly. This is not a time to be shy; if it makes any objective sense, ask your host if you can be moved to a different spot. Follow this rule of thumb: If given the choice, go first. If you can't go first, then go last—unless there's a very large agenda. (If you are stuck in the middle of a panel of speakers and it's not a discussion format, get up and move to the host's

podium to deliver your speech. Public speaking is not the time to be modest. If it's a discussion format or you simply can't get to the podium, act and speak as if you are the first speaker by pausing to take a deep breath and establish a different tone and pace than the preceding speakers.) If still stuck toward the end of a panel of speakers, one quote that will break the monotony: "I feel like Pamela Anderson's latest boyfriend: I know what I am supposed to do, but I am at a loss as to how to make it different."

The importance of introductions: You need to know *exactly* what the moderator or host is going to say about you. This should not be left up to the moderator to take from your resume. Whenever I am invited to speak at an event, I'm invariably asked to send my resume. Instead, I ask them how long an introduction they are planning. Then I either write one for the moderator to deliver verbatim, or I send along my resume with specific directions and highlights on the particular items I want mentioned in my introduction. Again, this is NOT the time to be modest. You want your audience to know how expert you really are and there is no better way to do that than to have the host do it for you.

Assuming you prepared your introduction, you still need to make sure the moderator pronounces your name correctly. If possible, ask him/her to say

your name a few times in the introduction. I know this is not typical, but people rarely remember someone's name when hearing it only once, and you are not going to be saying your own name in your speech. Obviously, it's best to have a name card in front of you or pasted to the podium. I once had the obligation of introducing a speaker who had a very difficult name to pronounce. He was a very affable person, but he made it clear to me that it was important to him that the audience remember his name. So, I used this opportunity to add a bit of humor to my introduction. I intentionally and humorously mispronounced his name three different ways. And then, as I obviously looked over at him and his red face, I affectionately explained to the audience that I knew his name well; however, because it was so often mispronounced, I thought this bit of fun would help the audience remember it. His red face turned to one of pride and appreciation.

If you are speaking to a large and sophisticated audience, you may want to consider using a video clip as your introduction. For such a device to work, the video should be from a legitimate source. As an example, if you have been interviewed on a news program and you have a clip showing a respected TV reporter introducing you, you may be very well served by simply playing that video as your introduction. A TV reporter's introduction would

provide instant credibility that your "live" host may not be able to provide—almost as if you are a TV star.

5. Know Your Audience

Knowing your audience is *fundamental* to the delivery of any good speech. It is also an effective way to prevent stage fright.

"Captatio benevolentiae" means: To capture the goodwill of your audience. You want the audience to accept you. Because, if they like and accept you, they are much more likely to listen and remember what you have to say. It is my theory that the most effective way to capture the goodwill of the audience is to "Know Your Audience" and to "Know Their Needs."

Have your moderator or host provide you with the following essential information. It's a good idea to get this information as early as you can in your preparation leading up to the date of the speech.

- How large is the audience?
- What are the demographics of the audience (age, gender, socioeconomic level, knowledge level)?
- Specifically, why are they there?

- Are members of the press in attendance or are you otherwise being recorded?

- What does the audience want to hear most?

- What does the audience want to hear least (sensitive issues)?

- What do you have in common with members of the audience?

- Will they just have eaten or been sitting for three hours and in need of a break?

Size Matters: Let's start with the most basic question, "How large is the audience you are going to address?" It is much different speaking to 20 people than to 100. If the group is more intimate, you can literally wade into the audience and speak as if you are having a conversation with each of them. In that case, I also strongly recommend asking each of their names so that you can engage them personally. With a larger audience, you need to worry about how you will project to them. Is there a microphone or will you be asked to shout your speech? The larger the audience, the more you must strive to keep their attention because it's much easier for them to be distracted or to feel more distant from you. This may seem like a simple concept, and it is. With a large audience, you must endeavor to pull the back of the room to the front. You do this by raising your

voice level as if you are speaking only to them (not just the ones in front) and directing your questions and interactions, first and foremost, to the back of the room. If you aim toward the back rows, your front rows will be covered automatically.

Know the Demographics of Your Audience: Once you've researched the size of the audience, you need to start drilling down to figure out the basic demographics. This is not easy, and yet it is essential to giving a good speech. You will speak differently to teenagers than to senior citizens. Your intended humor may not sit as well with women as with men. If your audience is primarily composed of women, make the humor appropriate to them. This is not just a question of gender and age. You must take the time to figure out the basic socioeconomic level of the audience in order to fully reach out and engage them. No, this doesn't mean you need to know the salary level of everyone present, but you would speak differently about driving and automobile safety to college students than to an audience of Teamsters. The education level of your listeners affects the topics you will be discussing and the kinds of words you will be using. An entertaining example of this was provided by the famous film director, Stanley Donen. When he received his Honorary Oscar® in 1997, he correctly assessed his audience by opening his acceptance speech with a very short tap dance

and then delivering his "thank-yous" by singing them to a famous tune, "Heaven, I'm in Heaven…"

This is why you will often see speakers begin their remarks by asking certain basic questions to assess the gender, age and knowledge of the audience. Chances are they already know this information, but it's a good idea, not only because it allows the speaker to know the audience better, but because it's also a simple way of immediately connecting with listeners by making them feel that you want to know about them. Importantly, by asking for a show of hands, you are already engaging your audience and making them participate (more on this later). Why even wait until the start of the speech to ask these questions? You can inquire about the audience even before you accept the speaking engagement. If a host isn't available, do research on the internet about the group you will be addressing. Or, if none of that is possible, arrive early enough to do your own demographic research in the lobby, greeting a few of the attendees to learn about them and to know a few friendly faces in the audience.

Know the Needs of Your Audience: Is your audience there because they were required by their employer to attend or because they need to spend a certain amount of time for professional accreditation? A captive audience is more difficult to engage than a voluntary audience who chose to attend. Treat a captive audience as if they all are from Missouri, the "Show Me" state—

you need to prove that you're worth hearing. If they are there by choice, they've come to hear you and they tend to be more tolerant and accepting in their response.

In order to better understand this point, let's look at Abraham Maslow's "hierarchy of human needs." His time-tested "pyramid" theory defines how humans first attend to their most basic needs (at the bottom of the pyramid), which are mostly physiological (e.g., eating, finding shelter). As humans satisfy these basic needs, they then attend to their higher needs (top of the pyramid) such as esteem, love and, ultimately, self-actualization. In addressing your audience, you should observe this theory by directing your points toward satisfying their most relevant needs. When speaking to an audience of 20-year-old college students, you are pretty safe in assuming they want to hear about finding jobs and finding mates. Is that a safe assumption when speaking to a group of successful retirees?

As a personal example, I can tell you that Maslow's theory is important to remember even when addressing a group of people from the same organization. Serving as Executive Director of the Producers Guild of America, I know that one of the primary issues facing our members is the protection of their producing credits. However, when discussing this all-important issue with my membership, I have

to take into account that a sizable minority of my audience is not enthusiastically attentive. Why? Because they are trying to find a job. It's hard to ascend to the top of that pyramid to address issues about receiving proper producing credits when you aren't working and have to feed a family. So, following Maslow's theory, I make sure that my speech addresses both issues—getting jobs and protecting credits—or I carefully explain how their support of protecting credits will lead to their getting jobs.

There is another reason for studying Maslow's pyramid of needs: It helps you to think of the audience's immediate needs. Remember that Maslow's theory states that people will first deal with their basic needs before they can attend to their higher needs. For example, if students are listening to a speaker in their search for knowledge, but they've been sitting for three hours without a break, the speaker must first attend to their most basic needs. If your host isn't astute enough to know their basic needs, take it upon yourself to enlighten your audience by giving them a short break to lighten themselves.

6. Check Your Appearance!

It is very important to dress appropriately for your speech. Nothing makes this point more clear than the Nixon-Kennedy debates. Experts pretty much agree that Richard Nixon was a better debater and more informed due to his years of experience; however, his sweaty, pasty appearance in an ill-fitting dark suit made him pale in comparison to a tanned, well-dressed John F. Kennedy. Many of those who only heard the debates on radio thought Nixon had won! Avoid Nixon's mistake: in the few minutes before your speech, check your appearance.

Get to a bathroom and in front of a mirror! Before giving a speech, it is absolutely essential to check yourself in the mirror immediately before speaking. This last-minute check is best done in a bathroom where you have a modicum of privacy and won't feel guilty about taking a good, long look at how you will appear to the audience.

Can't find a mirror anywhere? A mate will do! If you don't have access to a mirror, this is where spouses come in handy. My wife is most excellent at

pointing out to me whenever I have some dry skin peeling from my nose or hairs growing out of strange places. And it's important to check your teeth to make sure no pieces of olive or spinach are stuck to them.

Hair and Makeup: Do a last-minute check on your hair, in case it may have been tossed in the wind before your arrival. Nothing looks as goofy as tossed hair. And, if you have a lack thereof and you are speaking on a stage with bright lights, you should consider using a few dabs of makeup to tone down any potential glare. If you are wearing makeup, it is essential that you check how your makeup will look under bright lights and with the backdrop of the stage behind you.

Tell me it snot true! What if you experienced some mucous expulsion without being aware? This means that you may have something hanging from your nose. This is another good reason step in front of a mirror before you go onstage.

Get rid of your coins! Remove all coins from your pockets. At some point in the speech, you may unconsciously find your hands in your pockets fidgeting with your change. This can only be distracting to you and the audience, so get rid of your change before taking the stage.

Zippers are from Hell! Do I have to mention that you should always check your zippers to make sure they are closed BEFORE you go on stage? Later, I will be advising you to "reveal" yourself to the audience; this is not the way to do it.

Drink only water before speaking! To combat dry mouth, drink some water before speaking. It's also a good idea to bring a bottle or glass of water with you to the podium if you get dry mouth onstage or in case you need to buy some time during your speech. As a general rule, do not drink alcohol. Under no circumstances should you drink anything carbonated right before speaking. Even though it may be unintentionally funny, you don't want to burp, or cover a burp, during a speech.

Jewelry: Jewelry that is obvious to the audience is not good for the speaker. Jewelry is distracting. The only exception would be a speech that deals specifically with jewelry. It's not the focus you want to give when you are speaking. Worse, many speakers can't help fidgeting with their jewelry while they talk. If you feel naked or uncomfortable and <u>must</u> wear something, keep it modest and not flashy.

"A good speech is one with a good beginning and a good ending, which are kept very close together."

—Anonymous

7. Smeathing

What else can you do to get your audience to like you so they'll listen and remember what you say? I strongly suggest you start your speech by "smeathing." "Smeathing" is a made-up word to help you remember possibly the best advice this book will give you. It's also the first and last thing you need to remember as you start your speech.

SMILE WHILE DEEPLY BR**EATHING**

It is a proven fact that people like other people who smile at them. If you don't believe me, simply smile at the next stranger you see and I'll bet you s/he smiles back at you. Not only does smiling make people like you, you will feel better and happier whenever you do it. It seems simple but it is so true. Try it right now: Look at yourself in the mirror and give yourself a big smile . . . with feeling. Don't you feel better? The other part of this advice is just as crucial: take a good deep breath before getting into your speech. Breathing deeply a couple of times before you begin to speak does several things for you—and they're all good. Breathing deeply gives you a moment to collect

your thoughts while bringing oxygen into your lungs; this oxygenates your blood and helps your brain think better and more clearly. Deep breathing also allows your throat and stomach muscles to relax— therefore relieving tension and stress and preventing stuttering or stammering.

While smeathing, there are several simple relaxation techniques which you also may find helpful. First and foremost, concentrate on your breathing; you should be breathing calmly and deeply, not in shallow, hurried breaths. If you are by yourself, you can now start doing some stretching exercises that will release anxiety. All should be done slowly while breathing deeply:

- Twist your back from side to side

- Rise on your toes and then rock slowly back on your heels, concentrating on not tipping over

- Try bending over slightly to stretch your back and abdominal muscles

- Roll your head in circles—left to right, then right to left

- Do facial exercises by raising your eyebrows and stretching your mouth while raising your arms above your head

Again, it is most essential to keep breathing slowly and deeply while you do these exercises. Obviously, if

you are seated in the audience, it will be difficult to do many of these exercises without embarrassing yourself. If seated, do your breathing exercises while you stretch your feet by rolling them from toes to heels and back again. Concentrate—really concentrate—on your breathing by placing your hands on your stomach and taking long breaths that not only make your chest expand but, more importantly, your diaphragm.

Remember that first impressions are vitally important! When you get to the podium, take a deep breath and smile with feeling—give the audience that moment to take you in and give yourself the opportunity to make eye contact with them. If you are smiling while you are looking at their faces, you are connecting with the audience and they know you aren't afraid of them. Look at them as if they are your friends because for those few precious first seconds, they are! They want you to speak well and be confident; they want to learn from you and they want to like you because they can see your smiling and confident face! And, don't be afraid to wink at a member of the audience or tip your head their way or give a knowing squint to someone. If the lights are too bright for you to see the faces of your audience, take these few smeathing moments to visualize yourself on that stage, smiling and confident. DON'T LOSE THIS MOMENT WHILE YOU ARE SMEATHING BROADLY!

"The mind is a wonderful thing. It starts working the minute you're born and never stops working until you get up to speak in public."

—Roscoe Drummond

8. Say "No!" to Stage Fright— Remember, the Audience is on Your Side!

As I mentioned, one of humankind's most primal fears is giving a public speech. Effective public speakers utilize stage fright as a motivator. Embrace the "thrill" of it! Your speech is an opportunity to persuade people to act, convince them of something important or entertain them so that they leave feeling good. If you experience stage fright, here are some time-tested tools to help you conquer your fears:

Remember that the audience is on your side. Your audience knows what you are feeling and they really do want you to succeed. They certainly sympathize with you. They also want to have a good time or learn something from you and they know they're more likely to receive that "payoff" if you are confident about speaking to them.

Use positive thinking. If you push out all your negative, fearful thoughts, there won't be any room for stage fright. The great orator and optimist, Dale Carnegie, went even further by recommending that you:

Draw yourself up to your full height and look
your audience straight in the eyes, and begin to
talk as confidently as if every one of them owed
you money. Imagine that they have assembled
there to beg you for an extension of credit. The
psychological effect on you will be beneficial.

If you are uncomfortable assuming the role of a loan
shark, simply remember that the audience is there to
see and hear what you have to say. You were chosen
to speak to them because you have some knowledge
or experience that they <u>want</u> to hear.

Visualize silly situations. Try to place yourself in a
position of feeling more confident and in control
than anyone else in the room. One way of doing
this is to think of the audience in a peculiar way.
As a vivid example, Winston Churchill reportedly
liked to imagine that everyone in the audience was
completely undressed!

Focus on individual members of the audience.
Speak directly to individual members of the audience
and ignore the rest of the "sea of faces." Think of
yourself conversing with an acquaintance.

Concentrate on the clarity of your speech. Anxiety
creates adrenaline in your body and adrenaline causes
two less-than-helpful impulses: fight or flight. Clarity
of the mind, directly and chemically, counteracts the

production of adrenaline—if that clarity is about the organization of your speech and <u>not</u> about how fast you can get out of the room. Do not allow your mind to wander back to the audience and your stage fright; always go back to memorizing the first few words of your opening or the basic outline of your speech.

Use relaxing techniques. This is where your breathing and relaxing techniques will serve you well. If fear starts to well in your stomach, the most effective way to combat that sensation is to focus on your breathing. Remember, breathe slowly and deeply, not shallow and hurriedly. And don't forget your relaxing exercises!

As a last resort, you can simply confront your fears. If all previous exercises have failed, you may choose to share your fears with your audience. Most experts don't recommend admitting your fright to an audience, and I only suggest it here as a last resort because it will serve that all-important function of connecting with your audience. If you get to the stage and you are at the point of stuttering or freezing, then it is okay to say these ten magic words out loud: *"Well, at least I'm not nervous about giving this speech!"* You see, it isn't an apology and it very likely will receive some knowing laughter from the audience. Again, don't do this as a set opening; if you aren't sincerely experiencing stage fright, those ten words lose all their magic.

"One must not only believe in what one is saying but also that it matters, especially that it matters to the people to whom one is speaking."

—Norman Thomas

9. Turn Up Your Enthusiasm!

You've overcome your stage fright, you are consciously smeathing and you are ready to deliver your speech. Now is the time to turn up the dial on your enthusiasm! There is an old saying that enthusiasm will find solutions when none are apparent, and it will achieve success where none is thought possible. Why? Because enthusiasm is contagious. The more you are able to exert the energy to expose your audience to your enthusiasm, the more likely the audience will join you and accept your message.

Enthusiasm is essential to good public speaking and it takes two forms: being enthusiastic about your subject and being enthusiastic about your audience. This is not hard to do. Why are you speaking? Either you are passionate about your subject or you are excited about teaching something that only you can convey. So, you already have the motivation to be enthusiastic; now you have the duty to show that enthusiasm to your audience. If you need an image for motivation, simply think back to Sally Field's acceptance speech when she won her Oscar® for

Best Performance by an Actress: "…I can't deny the fact that you like me, right now. You like me! You really, really like me!"

How do you create your own enthusiasm? A good way to conjure it up is to think of delivering your speech with "passion." If you can convey excitement or passion to your audience, then you will be seen as having that most valuable and rare commodity: CHARISMA.

CHARISMA = ENTHUSIASM + SINCERITY

Another way of saying this is put your heart into your speech. *Show* that you care about your audience and your topic by exposing your emotions. Offer personal experiences about your topic that make you feel enthusiastic about telling them. You need to focus your energy on showing and explaining the emotion you are feeling. It's like sending out your energy, helping the audience to "collect" that energy and, in turn, send it right back to you. This theory applies to happy emotions during a best man's speech at a wedding, as well as sad emotions felt during a eulogy. The important thing is to convey that sense of energy that can be felt by the audience. I think Gore Vidal had that in mind when he humorously said, "I like the way you always manage to state the obvious with a sense of real discovery."

10. For Openers . . .

An "opening" is NOT your introduction. Your opening is the first few seconds of your speech where your primary goal is to have the audience identify with you. As far as they are concerned, your opening is the most important part of your speech. The old axiom is not far from true: "If you begin and end powerfully, the audience will forgive a weak middle."

It may not seem fair that so much rides on the opening of your speech because this is when you are the most likely to be anxious and uncomfortable. It's also when the audience sizes you up. If you don't win them over in the first couple of minutes, you'll have a very hard time getting them back. In those first few minutes, you need to establish your credibility, connect with your listeners, set the tone for your speech, describe your main theme, provide a sign as to how you want to conclude and build the bridge to the body of your speech.

Review the following forms of openings. Choose one that will best allow you to reveal yourself to your audience:

Short Personal Stories: Rarely is there a single best way to approach an aspect of public speaking. This is the exception to the rule. If you go with this option, you should do your utmost to open with a sincere story that serves your purpose while revealing something personal about yourself. It doesn't need to be a long story; in fact, for your opening, it should be a very short, anecdotal story. In 2001, Russell Crowe provided such an example when he won the Oscar® for Best Actor for his performance in *Gladiator*. In three sentences, he connected with millions of viewers by revealing a small part of himself that was universal to all: "When you grow up in the suburbs of Sydney . . . or the suburbs of anywhere, a dream like this seems kind of ludicrous and unobtainable. But this moment is directly connected to those childhood imaginings. And for anybody who's on the downside of advantage and relying purely on courage, it's possible." Not only does a personal story put the audience immediately on your side, it helps with your delivery because you should have no fear of memorization when you're speaking from experience. The ability to tell short personal stories is so important to your speech that I have devoted a later section of this book to it.

Uniqueness: This involves avoidance of clichés and "windups." Instead of starting with "Today, my talk will focus on . . ." get right into your topic. Don't

speak about what you are going to say; say it. If you have to thank your host or give background on your credentials, start with your unique opening and save the boring stuff for later, or weave that information and your acknowledgments into your opening. You only have a few seconds to win over your audience; those few seconds are at the beginning of your speech.

Questions or Challenges: A very effective way of opening a speech is to pose a question to the audience. If you can think of a question that the audience will find relevant to their particular interests, you have found a natural way of connecting with them while building a bridge to the body of your speech. I have found this technique effective, especially if I can ask the question in general and then pick out selective "leaders" in the audience to whom I ask the question directly, and by name. A slight derivative of asking a question is to directly challenge the audience, like asking them to raise their hands whenever you use a certain buzz word. This technique is best illuminated by an experience I had while participating in an incredible program organized by the Department of Defense, called the Joint Civilian Orientation Conference. As part of this program, a group of "civilians" were allowed to visit with the troops of the five branches of our armed forces throughout the United States. As we flew from base to base, we'd be introduced to

a general who would tell us about his/her branch of the service and give us the opportunity to meet with his/her troops. What became quickly obvious is that all generals overuse acronyms, to the point that most civilians wanted to go AWOL while they were speaking. One of the generals was quite smart by acknowledging the practice and challenging us to catch him using an acronym without explaining it. If anyone in the group caught him, he'd give them one of his shiny military coins. We all listened more carefully to his speech than any other.

Video Clips: If short and to the point, a video clip can be an effective way of opening your speech; however, it is essential that the video clip be directly related to YOUR opening and not a separate video. Obviously, this is easiest to do if the clip involves footage of you. For example, if your speech is on effective tools of child-rearing, it might be humorous and informative if you started your speech with a short video of your interaction with your own kids. Finally, the clip must be short and to the point. A long video will do just the opposite of your intentions; it will alienate the audience and make them mere spectators.

Humor: Nothing is more effective than opening your speech with a good joke that is funny and on point. When you are able to make an audience laugh, they feel good and immediately attribute that good feeling to you. It is something to aspire to, and yet, it is a very risky path. You could be a hero, as I've already described, but what if your joke is not funny? It is a very rare speaker that can recover completely after telling a bad joke, especially if the joke is off-color or inappropriate. Even if your joke is funny, you still miss the target if it is not on point to the topic. Yes, it's good to make the audience laugh, but if the joke does not naturally lead to the material of your speech, you will have confused your audience, or worse, maybe misdirected them into thinking that you're there only to entertain them, rather than to inform, persuade or convince them. Remember, the first and foremost goal of your opening is to identify yourself with the audience.

Topical News or Factoids: If you can open your speech by using relevant information taken from the local newspaper, you are already telling the audience that you care about what's happening to them. And, if you can put a humorous twist on it, all the better. Again, use whatever tool you can find to connect with your audience—identify yourself with them. Why do you think so many touring musicians open their sets by yelling how much they love the

particular city in which they're playing? If you are pressed to find something in the news that is topical and interesting, you may want to research a factoid about your location or the date of your speech.

Quotations and Aphorisms: Using a quotation is very similar to using factoids or topical news to open your speech; it's good only if relevant to your audience and the theme of your speech. If you can find a quote from a famous person, you will connect with most people by showing that you both agree on the importance of the quote and the relevance of the person quoted. As an example, you may have noticed that I started this book with a quote from one of my favorite authors, Jonathan Swift. For me, his comment echoes not only what I think, but what I believe many of the readers of this book think. You also may want to briefly state the context of the original quote, maybe even something interesting about the author or the place where the author gave the speech. In essence, you should attempt to tell a personal story, revolving around the quote, that's interrelated with your topic. An aphorism is very similar to a quote, usually being a quote from an anonymous source, one directly and personally familiar to you and your audience. For instance, if you were speaking in the "deep south," you might open with a comment that "there's nothing as sweet as southern hospitality."

You are immediately providing the other element that should, whenever possible, be included in an opening, which is. . .

Flattery: Yes, your mama was right: flattery does work . . . if it is sincere. This is the most commonly used tool in an opening—graciously thanking the audience, acknowledging the beauty of their town or noting the intelligence of the attendees. But why not take this one step further to guarantee its sincerity? Take a moment to do a bit of research to ensure that your flattery is based on fact and totally relevant to this particular group. If you are speaking in a foreign city at a convention composed of people from distant locations, it's not going to make much of an impact if you compliment the convention city.

Retrospective/Prospective: Many effective speeches are opened by looking back in time and describing what was. It's a version of telling a personal story and is usually teamed with a contrast to what can happen in the future. This is an opening that can get you right into the meat of your speech without having to worry about bridging from the opening to the body of your talk. It will all stem from your ability to pull a retrospective example that identifies you with the audience. This was the technique that Mr. Lincoln used in his historic Gettysburg Address, when he harkened back to the formation of the

U.S.A. in order to put the current grim situation in historical perspective and to point the audience to a historically significant future. (Of course, because Mr. Lincoln's speech only lasted a couple of minutes, his opening was also his closing.)

11. Speak with Confidence

If you speak with confidence, the audience will imbue your words with sincerity. And, good preparation is the best way to build your self-confidence, which is also very much a question of presentation and how you look. There is an old saying that bears repeating here: "Great speakers listen to the audience with their eyes." Stand up straight, look directly at the audience, establishing eye contact with as many people as possible, and use an authoritative tone when discussing those things about which you are knowledgeable.

"Always be shorter than anybody dared hope."
—Lord Reading

12. Never Apologize!

One cardinal rule that applies to any opening:
NEVER APOLOGIZE TO THE AUDIENCE. (The only
exception to this rule is if you arrived late or your
apology is the setup for a funny and relevant joke.)
This rule is often violated and while it doesn't spell
doom, it does start you out in a bad light. You are
there because the audience has been told you have
something important or entertaining to tell them.
Your goal is not to be subservient; rather, it is to
identify yourself with the audience.

"The public speaker who drives home too many facts will also drive home too many listeners."

—Anonymous

13. Involve the Audience

A good way to build enthusiasm and ensure that the audience is listening is to provoke them to action. ENGAGE your audience by making them DO something instead of just passively listening. This point is so true, it's been memorialized in the old Chinese proverb:

I hear and I forget
I see and I remember
I do and I understand

If you think of your audience as your partner, you want them involved with you. Why not ask them for their involvement? Figure out ways to get your audience standing, voting, shaking hands with each other or simply applauding. I use this technique in virtually all of my speeches. During my first year serving as Executive Director of the PGA, I was giving a speech at my first General Membership meeting and I wanted to do something with the members that would be memorable. My speech dealt with the fact that producers, as a general rule, tend to be independent entrepreneurs who don't

think collectively. However, the Producers Guild represents just that: collectivization of producers. Many of my friends said that trying to put producers together to think collectively would be like trying to herd rabbits. To demonstrate my point and motivate audience participation at the same time, I asked the membership to prove my friends wrong. I said that I could illustrate, with a simple exercise, that producers could stand together and support one another. How? I challenged them to get up and hold hands with the people on either side of them to express their mutual respect and support. Sure, there was some hesitation, but I urged them to overcome their embarrassment and show their unity by reaching out. To my amazement, not only did every audience member stand and join hands, the first row stretched forward—never breaking ranks—and wound up to the stage to include the Guild officers and myself. They showed real solidarity that day, which has never been forgotten. I've been teased about it at each subsequent meeting . . . and membership has multiplied every year! My point could never have been made so forcefully with just words. Take a moment to think about how you can bring home your point more powerfully with audience participation. Here are some easy examples to ask of your audience:

- Raise hands
- Stand to be counted

- Hold up a certain number of fingers
- Shake the hand of their neighbor
- Exchange seats with their neighbor
- Stamp feet
- Clap hands
- Snap fingers
- Respond verbally

"Speeches are like babies – easy to conceive but hard to deliver."

—Pat O'Malley

14. Handling Handouts

As a general rule, "handouts" should not be passed out until the end of your speech. This may go against conventional wisdom or common practice, but just take a moment to think about the process. What are you doing when you stop your speech to pass around handouts? Well, first you are stopping your speech. There goes your continuity. And second, what is happening when the handouts are circulating? Noise and disruption are only interrupted by the audience's attention being diverted to . . . what? Back to you? No. You are intentionally diverting their attention to the paper in front of them. You have lost eye contact and when people read, they stop listening. You have just said good-bye to your audience connection!

"The best time to end your speech is when you feel the listening is lessening."

—Anonymous

15. Wrap Up Quickly and Exit Gracefully

Your conclusion should very briefly restate your main points, evoke a desired response from the audience and leave them feeling a sense of completion.

Use short sentences in your conclusion and use powerful words—words that don't leave any doubt or equivocation. If the purpose of your speech was informational, it is helpful if your conclusion summarizes your main points in parallel sentences so that all members of your audience end on the same beat or tempo. A quotation can be a good closer if the reference is directly on point and the source is renowned. If the speech was intended to entertain, your most vivid illustration, story or joke should be your closer. If the purpose of your speech was to persuade to action, impress or convince, then it is always recommended to have an emotional "call to action" as your close.

But absolutely—and most importantly—your conclusion must be like this one: short. Think about it: Have you ever heard of anyone attending a speech and commenting afterward, "Gee, I wish she had

spoken longer"? No. The most common complaint about all speeches is that they are too long.

16. Now, Don't Beat Yourself Up!

Whether it is human nature or learned behavior, you may be tempted to follow your speech with self-doubt and recriminations. Don't! This is easier said than done. We often are advised to judge ourselves and our performances in order to improve for the future. However, when it comes to public speaking, self-analysis is often negative and mostly inaccurate. The first thing to do is to congratulate yourself for tackling one of life's most difficult tasks: SPEAKING IN PUBLIC. Next, let some time pass without saying to yourself, "I shoulda done this . . ." or "I shoulda not done that . . ." Finally, and only with the understanding that you are doing so in order to enhance your next public speaking engagement, seek out a few members of the audience and ask them for their honest feedback on your speech. Then, take that constructive criticism and apply it next time.

"It usually takes me more than three weeks to prepare a good impromptu speech."

—Mark Twain

Prep Work in the Days Before the Speech

We've already dealt with what you need to do in the final minutes before your speech. If you've been lucky enough to find this book a few days before your presentation, the next few sections will give you all the tools you'll need to prepare and write a successful speech.

A. Taming the Monster: How to Structure and Organize Your Speech

Every good speech has a theme. Every great speech serves its purpose by sticking to that theme. The theme is the central idea or topic for the speech, and it should be supported by facts, examples and logical discussion.

To illustrate this definition, let's examine a common speech whose primary purpose is to entertain: The best man's toast to the bride and groom. What is its theme? To celebrate their love. Such a speech is properly supported by using personal—hopefully humorous—examples about the blissful couple, maybe including a brief history of their relationship

and the sorrowful condition of the groom before he was lucky enough to find his bride. . .or vice versa. Your theme is even more important if the purpose of the speech is to inform, convince or motivate to action. It should be very specific and reducible to a single sentence. The more narrow and simple it is, the more likely your audience is to receive and respond to its message. And, to show you that even the most famous of speeches can be pared down to one thematic sentence, here is my idea of what President Lincoln's theme was for his Gettysburg Address (which will be analyzed in detail later): Honor the men who died on the Gettysburg battlefield by achieving the goal of our forefathers of forming a united nation in the pursuit of freedom for all.

Please take the time to think clearly about what you want the audience to come away with after listening to your speech. Your immediate reaction may be to think there are several important points you want to convey. Invariably, this is true. However, it is up to the speaker to organize those points and determine which one is the most important, and then organize the others as subsidiary to, or supporting, the primary theme.

1. Begin with thinking: What does the audience want to hear?

Is the audience attending your event to hear you

speak about a theme you have picked? Is it important to the audience? Is it going to benefit them? Is it what they are seeking? If you can't honestly answer these questions in the affirmative, NOW is the time to select a better, more interesting and more audience-directed theme.

If there were other themes of your speech that you initially thought were subsidiary, consider whether one is more in line with what the audience is seeking. The point is to maintain relevance and interest. If a theme has been assigned to you, your job is to choose the structure that best supports that theme.

2. Pick a theme and structure

You have a purpose for speaking to your audience and you have succinctly defined your theme. Make sure your speech is organized in the best possible fashion so that your target audience will feel connected to you and will take home your message.

Analyze the components (points) of your speech and how they are organized to relate to your theme. The audience must be able to easily follow the flow of your speech, much like following a map, to your conclusion. Cut, cut, cut any material that does not serve your purpose or relate directly to your theme.

There are several structures upon which to build your speech. No one can say that one organizational

framework is best for all speakers. It is up to you to pick the one which best suits not only your purpose and theme, but also your style of delivery:

- Basic

- Narrative

- Problem > Solution

- Cause > Effect

- The Magic Formula

- Compare and Contrast

- Elimination of Options

- Alphabetical or Numerical—Your Last Resort

The "Basic" Speech Structure: The basic organizational structure is flexible enough to accommodate all types of speeches, whether to inform, impress, convince, persuade to action or simply to entertain:

- Opening

- Purpose and thesis

- Discussion of main points (try to keep to three or less)

- Conclusion

This basic structure will move your audience from "why" to "how." The speaker begins (the "opening") by explaining why his or her comments are important to the audience. The speaker then takes the audience on a journey to inform, convince, entertain, etc. Such a journey must have a clear structure and shouldn't be burdened with more than three central points. It's too difficult for most listeners to grasp more than three primary ideas in a speech.

The "Narrative" Structure: If your speech is primarily intended to be entertaining, a common practice is to use the "telling-a-story" approach. This structure also can be useful in conveying information in an interesting and entertaining way. You must remember that simply telling a story doesn't mean that your audience will listen. You must endeavor to make the story personally relevant and keep it organized in a basic structure with an opening thesis, a discussion of the main points of your story and then the conclusion. Of course, you may very well utilize a narrative style as part of a convincing or persuasive speech, but typically for such speeches, you would need to conclude with some form of call to action as opposed to merely ending your entertaining story.

In utilizing a narrative structure, many speakers rely on telling their story in a chronological order. Be

careful with such a structure; it can get boring. That is why you are advised to make your chronological listing part of a narrative or story that has personal relevance to the audience.

An award acceptance speech, or any speech where the speaker is basically thanking members of the dais or audience, usually involves a basic narrative form. Unless the speaker is simply saying "thanks," s/he should endeavor to interweave "thank-yous" with humor or personal stories. Robin Williams provided a very good example of this in 1997, when accepting his Oscar® for Best Performance by an Actor in a Supporting Role: "Thank you for putting me in a category with these four extraordinary men. Thank you Ben and Matt -- I still want to see some ID. Thank you, Gus Van Sant, for being so subtle you're almost subliminal."

Robin Williams' speech exemplifies my "Four-H Rule" for giving a memorable acceptance speech. Start from the Heart, season with Humor, reveal your Humility and end with Haste.

The "Problem > Solution" Structure: Moving from simple to more complex structures, one of the most common and effective methods is to take the audience from analyzing a problem to showing them the solution. Most sales pitches utilize this organizational structure in its simplest form. Example:

"Can't get rid of that ring around the bathtub? Use Dutch Cleanser and see those rings run down the drain." But don't let the sales pitch mislead you into thinking this format is simplistic. Although more complex, it is a very commonly used structure whenever the speaker is trying to convince an audience or persuade them to take action:

- Frame the situation and context of your speech
- Present a problem for the audience to solve
- Offer your solution to the problem
- Suggest specific action the audience can take

Many believe that the best speech in modern history was given by Abraham Lincoln on the bloodied Gettysburg field. His speech eloquently illustrates the problem > solution structure. The context of the speech cannot be overstated. The battle of Gettysburg had just occurred and many soldiers had died, both Confederate and Union—all Americans. Lincoln's purpose was not to deliver a eulogy; it was to unify America. The entire speech was 286 words and took less than two minutes to deliver. Also important to the context of Lincoln's speech was that Edward Everett, the greatest orator of the time, had just delivered a talk lasting two hours.

Lincoln's Gettysburg address presents a fine model for all problem > solution-structured speeches.

He starts by hooking the audience into thinking about the horrible instance at hand in a historical setting. Remember, Lincoln didn't start by reflecting on the battle or the deaths. Rather, he started by framing his oration in the context of the history of the United States: "Fourscore and seven years ago, our fathers brought forth on this continent a new nation, conceived in liberty and dedicated to the proposition that all men are created equal." In one brilliant opening sentence, he makes the audience feel connected to each other and to him ("our fathers"), while placing it all within the grander framework of the birth of our entire nation, not just within the borders of the grisly field of war. Therefore, in his opening line, Lincoln laid the foundation and precisely defined where he planned to lead the audience.

Instead of praising those brave soldiers who had fallen on the battlefield, Lincoln presents a problem—or complication—to the audience: "… we cannot dedicate, we cannot consecrate, we cannot hallow this ground." Just think if you were in that audience and you were told that you could not grieve for those who had just died! This was a risk, and Lincoln could have lost his audience. Instead, he grabbed them with interest and expectation. If they weren't there to honor the dead, why were they there? This is an example of great storytelling. Your audience expects organization, but is won over by an unexpected twist, or a curious mystery.

Instead of commiserating with the audience in their collective grief, Lincoln presses them toward a solution: "It is for us the living, rather, to be dedicated here to the unfinished work which they who fought here have thus far so nobly advanced." Lincoln then concludes his speech by asking each member of the audience to take action: ". . .that we here highly resolve that these dead shall not have died in vain, that this nation, under God, shall have a new birth of freedom, and that government of the people, by the people, for the people, shall not perish from this earth." Yes, the action asked to be taken was a rhetorical one. But, if you were in that audience that day, don't you think you would have been saying to yourself: "I so resolve!"

The *"Cause > Effect" Structure:* This organizational approach is similar to the "Problem > Solution" structure; however, it is important to note that it does not start from a negative or a "problem." Instead it begins with an issue or event and then illustrates what may result from that issue or event. Typically, it is deductive or inductive.

- A deductive approach is one in which your speech starts with some sort of general rule and then goes on to discuss the particulars which lead the audience to predictions of future results.

- An inductive approach is just the opposite. Your

speech starts with an analysis of particular events or issues and then concludes with a general rule learned from that analysis.

The "Magic-Formula" Structure: If your speech could use elements from both Problem > Solution and Cause > Effect structures, and you want the audience to take a journey which will lead them to take your recommendation to action, you may want to consider Dale Carnegie's "magic formula." Mr. Carnegie was a grand salesman. His advice was that a speech should start with a detailed story, be followed by a clear explanation of what was expected of the audience and then conclude with very uplifting examples of how better off the audience will be by doing the things asked of them.

If you are at a fundraiser and simply ask the audience for money, you will probably not have much success. However, if you utilize Mr. Carnegie's "Magic Formula" (which could be properly described as a Problem > Solutions > Effects structure), you will be more likely to receive funding.

Example: At this same fundraiser, you start your speech with a personal story about your recent trip to a village in Africa, which you highlight with photos of the frail and impoverished villagers. You then explain how many lives could be saved by access to untainted blood,

or the services of a qualified nurse, or the contribution of vaccinations, followed by a clear example of just how far one dollar can go. Finally, you conclude by painting a vivid picture for each member of the audience, emphasizing how he or she will feel once they have chosen to make a small yet significant contribution. Can you hear the checkbooks opening?

The "Compare-and-Contrast" Structure: Under some circumstances, you may find it useful to organize your speech into a series of comparisons and contrasts. This is utilized in many boardrooms across the country when an executive is asked to compare the company's products with a competitor's. In political debates, this structure is useful to contrast one candidate's position on issues versus another candidate's position on those same issues. Many comedians also use this structure and the result is usually a very entertaining speech. Again, you still need to work your speech from an opening theme, followed by a discussion of various comparisons and contrasts, ending the journey with a solid conclusion.

The "Elimination-of-Options" Structure: A close derivative of the "Compare-and-Contrast" structure is the "Elimination-of-Options" structure. This allows you to start with your theme and then methodically remove various options until you end up with a workable one that serves as your conclusion and call to action. This

structure can provide for some good storytelling. In order to lead their audience to the desired conclusion, many speakers invent some very entertaining scenarios as options. Remember that the audience is rating your credibility with each eliminated option. If one of your options isn't realistic, or isn't eliminated in their minds, you may lose them. However, if you can illustrate your options in a humorous or entertaining way, your audience may be very willing to forgive you.

As an example, let's examine a speech that is intended to motivate your audience to lose weight. Instead of focusing on the problems associated with losing weight, it may be more positive and humorous to discuss and eliminate the options available to someone choosing not to lose weight: continuing to buy more clothes with increasing waist sizes, opting out on those fun sports activities your colleagues invite you to, foregoing the next company dance, developing funnier things to say when kids make rude comments to you after visiting the buffet table, etc.

"Alphabetical-or-Numerical" Structures—Your Last-Resort: If your primary purpose is not to entertain the audience, or to persuade or convince them, and yet you have a list of issues or points to discuss and you simply can't figure out the map for the audience's journey, then—as a last resort—you can provide your audience with benchmarks listing your

points alphabetically or numerically. If nothing else, this will help them to know when your speech will end and, if you've been at all successful, when to applaud.

3. Use an outline to help organize your speech

If you are having problems picking an appropriate structure for your speech, you may need to first prepare an outline in order to organize your thoughts and finalize your theme. Not only will an outline help you organize the structure, it also will help you: memorize your speech; focus on the points you want to emphasize; expose any deficiencies in your logic or flow; avoid tangential points or examples; and shorten your speech. Even if you do not subscribe to the theory that your speech should be written out verbatim, you would be ill-advised to continue without the benefit of at least a written outline to guide you.

HINT: If you are not able to fit the outline of your speech onto one page, either your speech is too long, it is not properly organized or it is not an "outline."

B. Striving for Clarity and Brevity: "Less is More!"

Less is More

After practicing your speech, you will get a good idea of how long it will run. More likely than not, it is too long. Once again, have you ever heard of anyone

attending a speech and commenting afterward, "Gee, I wish she had spoken longer"? No. The most common complaint about all speeches is the length.

Remember, the Gettysburg Address was only 286 words and took less than two minutes to deliver.

Your first consideration should be: How long have I been given to speak? Second: How long does the audience want to hear me speak? Your third consideration should be to memorize Franklin Delano Roosevelt's admonition to his son, James: "Be sincere; be brief; be seated."

Nothing is more important right now than to remove a few minutes from your speech. Delete the extraneous, the digressions, anything and everything that doesn't directly serve your purpose and theme. If you have been given five minutes to speak and your rehearsal comes in right at five minutes—your speech will run long. Rehearsals usually run shorter than the actual speeches. Therefore, you should plan to run shorter than the time allotted.

It is helpful to record your practice speech. That way, you can hear how you speak and know exactly how long your speech runs. The typical person speaks at 120 words a minute, but you need to double-check your REAL speaking speed. If you are speaking at less

than 100 words a minute, you are going too slow and risk boring the audience. If you are speaking at more than 140 words a minute, you may lose your audience because they can't keep up.

Keeping your talk short and succinct is the essence of a good speech. If any doubt resides in your mind, please consider the inaugural address of President William Henry Harrison in 1841. Despite the below-freezing temperature, he insisted on delivering his 9,000+-word speech, which took a full two hours.

Less than a month later, W. H. Harrison died of pneumonia.

Clarity

Strive for clarity. Clarity of your themes, clarity in your tone and clarity in your choice of words. Remember that the audience is expecting you to take them on a journey. If the road from the opening to the closing is not clear, you will surely lose them. Again, you must refer to your theme and outline. Are all your comments and points directly focused so that the audience can clearly see the connections?

Limit your subject. Stake out the area you want to cover and strictly stay within those bounds. In other words, you need to focus the attention of the audience on a very limited area of discussion.

Beware of clichés. When searching for a good illustration or example, many speakers slip into using clichés or hackneyed phrases that may bore the audience, or worse, make you lose credibility. You must strive to make your illustrations and examples unique, topical and personal. Only use clichés when you really mean to use them and you are certain that such usage won't offend your audience. The same goes for jargon and euphemisms.

Use concrete, familiar words that create pictures in the minds of your audience. Your goal should be to compare the strange to the familiar and to make the complex simple. Take note of what Aristotle is remembered for saying, "Think as wise men do, but speak as the common people do." I believe there is a second part to this point which needs to be carefully explored, and that is the use of colorful words to create vivid pictures in the minds of your audience. William Strunk, Jr. and E.B. White wrote in their useful book, *The Elements of Style*:

> The greatest writers—Homer, Dante, Shakespeare—are effective largely because they deal in particulars and report the details that matter. Their words call up pictures.

Use rhetorical devices to enhance the clarity of your speech. Rhetorical devices are very effective tools

that give the audience important cues and moments of familiarity. Here are a few well-known examples:

- Contrasts—"One small step for man, one giant leap for mankind." *—Neil Armstrong*

- Lists of Three—"I came. I saw. I conquered."
 —Julius Caesar

- Pictures with Words—"Madame, I may be drunk. But in the morning I'll be sober and you'll still be ugly." *—Winston Churchill*

- Personal Statements—"An ideal for which I am prepared to die." *—Nelson Mandela*

- Repetition—"Government of the people, by the people and for the people…" *—Thomas Jefferson*

- Signposting—"I have a dream." *—Martin Luther King*

- Query—"Have you no sense of decency sir?"
 —Joseph Welsh
 (to Senator Joe McCarthy)

- Alliteration—"In the Unites States today, we have more than our share of the nattering nabobs of negativism." *—William Safire*
 (for Spiro Agnew)

Avoid difficult or confusing words. Words can also be your enemy. Take the time now to go through and remove any objectionable or confusing words or phrases. Sexist language is never appropriate.

Additionally, try to avoid problematic or "weird" words:

- Homonyms—Words with multiple meanings that might be confused in context (e.g., affairs)

- Homophones—Words that sound alike but have two or more spellings/meanings (e.g., one/won)

- Tongue Twisters—Words or phrases that are difficult to pronounce

C. Effectively Using Charts, Props, Gestures and Visual Aids

Graphs, slides, audiovisual aids, tables, handouts, charts, etc., are all visual aids that can greatly enhance delivery of your speech IF you follow the cardinal rule: *visual aids are tools and not crutches.* Follow this very simple rule and you won't go wrong. Quickly take a moment to review your speech and analyze each place where you have inserted a chart or graph. If you refer to such visual aids in a way that illuminates your point, you are using them correctly. If, instead, you are relying on your tables, charts and slides as ways to help you remember the points you want to make or if they are intended to be self-explanatory, you should remove them.

HINT: Before using any visual aids, check to make sure they are suited for the room, the lighting, the distance from the podium, etc.

Charts, graphs and tables: It can be helpful to explain your points by showing a clear, readable and simple chart, graph or table. It is a way to support your point by helping the audience visualize your concept and understand it. You should make an effort to keep your visual aids readable and with little detail. When in doubt, leave it out. And, if you are simply taking charts, graphs and tables from a book and photocopying them onto a slide, chances are they won't be as effective as ones that are prepared specifically for your speech.

There truly is a science to the proper structure and use of charts, graphs and tables. From birth, we are trained to read from left to right, starting from the top. This is not innate or even universal; it's true for those who primarily reside in the western hemisphere. Think about it for a second: Why do most artists sign in the lower right corner? Because people involuntarily review their work starting from the top left corner and sweeping across from left to right until they end up in the bottom right corner— to appreciate the person who brought them there.

Accordingly, you should take this practice into account when constructing your charts, graphs or tables to minimize the number of "eye-sweeps" required by your audience. Your written points should be one line only (you don't need full sentences on charts!). Not only are readers conditioned to read charts as bullet points, they

are trained to think that the next line is a new topic. You should eliminate all unnecessary words, numbers, scales and legends. If you are using acronyms, make sure they are explained. Also, pluralized acronyms do not have apostrophes. It's IBMs and GEs, not IBM's and GE's. Very commonly, designers get carried away with different fonts and spacing. For the audience, it is better to not use more than two font styles or disproportionate spacing. That doesn't mean you should be afraid to have shading and boxes. Such devices tend to help the audience understand the important sections of your visual aids while reducing boredom.

The use of gestures for emphasis: Don't forget that some of your best "visual aids" are the ones that you show with your own body. People are often more attentive to body language than they are to the spoken word. Accordingly, make sure to use the proper gestures for emphasis. What's more effective in displaying disagreement: saying you disagree or pointedly hitting the podium? If you have three points to convey, why not emphasize each of them with a pointed outreach of your arm denoting the point you've covered? Be careful of unintended body signals, as well, such as crossing your arms. Crossed arms denote a closed or unreceptive demeanor. Also, never speak while looking down at the ground. Not only will the audience have a harder time hearing

you, they are less likely to believe you because you've lost eye contact with them.

Audiovisual devices from Hell: Okay, you've planned to use your visual aids correctly—to illuminate and support the theme of your speech. If a "machine" is involved with these visual aids, you are advised to follow Murphy's Law that if anything can go wrong, it will go wrong. Assume the electricity is going to shut off, the display screen will stick in the closed position or the electronic white board will stay black. Either have a back-up solution or be prepared to speak around the screwup by humorously commenting on it and moving on.

D. Connecting with Your Audience

"To Reveal is to Appeal" – The Three Reveals: During your speech, including your opening, your constant objective should be to reveal yourself to the audience through your personal experiences, stories and humorous adventures. To help you remember this important element, I call it the three "reveals":

- Reveal Yourself

- Reveal Your Humor

- Reveal Your Personal Stories

Reveal Yourself: As I hope you know by now, the goal

is to connect with the audience. Even though the speaker is doing all the talking, the audience needs to feel like the speaker is listening to them. If you are not able to convey to them that you are accessible, they are less likely to give you their attention. Being given the stage or podium, you have received immediate authority over the audience. However, you need to earn their respect and attention.

The most effective way to do this is to reveal some part of your personality or personal history that shows your accessibility and humanity. If you do this without sincerity, you will lose the audience. The truth is that the audience would rather hear a story about how you fell on your face than how you won your Yachting Club Sailing Tournament. What the audience is really seeking is a speaker who shares their common, human foibles.

When speaking about personal experiences, it is important to draw upon your *emotional memory* to relive those experiences with your audience as if you were going through them for the first time. Admittedly, this is not easy and it takes practice. As an example, if you decide to tell the audience about your anxiety in speaking to them, you should explain how and what you feel. "Before I walked up here, my hands began to sweat, my heart started pounding like my pacemaker battery had gone from AA to a 9-volter. . . and do you know how it feels when the

pit of your stomach starts to move up to the bottom of your throat?" In other words, don't just tell them, SHOW THEM.

Reveal Your Humor: The most effective way to earn the respect and attention of your audience is to tell a short, revealing, humorous story about yourself. Humor is a valuable aid because:

- Physiologically speaking, laughing relaxes people

- Laughing is synonymous with feeling good

- Revealing personal information makes the audience feel that you are accessible

- You have the complete attention of the audience (have you ever wanted to talk to someone when they are laughing? No; you only want to know why they are laughing so you can join them)

- Having received their laughter, you, too, are feeling relaxed and self-confident

The result is you have a relaxed audience that can't wait to hear what you have to say next. The only real risk is if your story is perceived as not being sincere. It's not a risk if it isn't funny; a sincere anecdote makes its point whether it's funny or not. The lesson here is that you should always try to use an amusing personal story relevant to your topic. Just make sure you aren't stretching so far that it begins to lack sincerity.

If you don't have a cute personal tale to share, turn
to something topical and put your own spin on it.
Observe the room, the day, the event itself or even
the audience. And please note that we're not focusing
on just a funny opening; search for ways to season
your entire speech with elements of humor. Think of
yourself in the audience—don't you love it when a
speaker weaves amusing comments or observations
throughout the speech? Still stuck? Well, here is
a simple hint: make a comment about the venue.
Typically, something always goes wrong there and
everyone in the audience is either talking about it or
thinking about it (e.g., parking problems, food service,
sound system). Again, this is your opportunity to
show the audience that you are just like them and
are thinking the same things they are thinking. Don't
lose this opportunity (but be careful that you aren't
making fun of a venue that has personal or historical
relevance for the audience).

This Isn't Funny:

- "I don't tell jokes, but …" or "I'm not a
 comedian, but …" (These violate three of our
 rules: never apologize; never use clichés; never
 tell a joke when you're uncomfortable telling it)

- "Here is the best joke I've ever heard …"

- Don Rickles-type humor is never appropriate
 for public speaking; you never want to insult the

audience unless you're a professional comedian hired to entertain

- A joke read, not told to an audience from printed material

- Telling jokes when you know you have no ability to tell them.

If you've told a joke that didn't go over well, you have two choices: move on and ignore it, or fess up and acknowledge that you are human and made a comedic mistake and will fire your joke-writer as soon as you get home. The former choice is usually preferable unless the silence after the joke is deafening and demands a response. If it's the latter, just smile broadly, with obvious embarrassment and say something that everyone in the audience is feeling . . . even "Ouch" is appropriate. You need to get the audience back on your side as quickly as possible. At all costs, keep a smile on your face and the appearance of good cheer; it tells the audience that you are still in command and know what's going on.

Is it better to risk some humor and not be funny or not to try at all? "Speech experts" disagree on this subject; I am of the opinion that it is better to attempt humor than to settle for boredom. Whenever I'm asked to speak, I remember the story of the "last man in the audience." He was in a room

at first filled with people. Unfortunately, there was a speaker who gave such a long and boring speech that eventually everyone left except the last man. Finally, the speaker looked up from his printed speech and addressed him directly by thanking him for his interest. The last man quickly responded: "What interest? I'm the next speaker!"

Reveal Your Personal Stories: People learn from stories. Take a moment to think about your own life's lessons and you'll soon have a story to tell. People rarely act based on intellectual information. Emotional information is more engaging and more memorable. Stories tell emotions and not facts. And your emotions cover a broad area and can be adopted to fit most themes.

• Anecdotes: An anecdote is "a short narrative of an interesting, amusing or biographical incident." If you don't have a personal story relevant to your theme, try to think of an otherwise interesting, amusing or historical incident or example. Can you relate your theme to some famous event in history, or some well-known theme of a current novel or film? It will be easier for the audience to understand your theme if you give them a colorful story which symbolically identifies its importance for them.

• Metaphors: A metaphor is defined as "figurative language in which a word or phrase literally denoting

one kind of object or idea is used in place of another to suggest a likeness between them." Metaphors are rhetorical devices used to provide images that will help audiences understand, assimilate and remember a speech. Use them often; use them colorfully; use them as you would use illustrations and pictures if you were writing a book. As an example, follow the direction of Ralph Waldo Emerson, who explained the value of a metaphor by using a metaphor: "Condense some daily experience into a glowing symbol, and an audience is electrified." Obviously, you don't want to literally electrify your audience, but your words should do just that.

• Similes: When a metaphor is phrased in a format that compares two things by using the words "like" or "as," you are utilizing a "simile." I hope this book will make your speech as powerful as a lightning bolt, as memorable as your first kiss and as rewarding as your very first paycheck. If you were speaking that last line, with properly enlivened delivery, your audience should be visualizing that lightning bolt as if it were happening in the room; looks of longing should cross their faces as they think back to their first kiss; and their faces should be left with smiles from the memory of cashing that very first check. It's all about creating vivid images in the minds—and hearts—of your audience.

Building Credibility by Showing Sincerity:

Dale Carnegie was unique in his success because he always underscored his enthusiasm with sincerity. As he said, ". . . it is necessary to set forth our own ideas with the inner glow that comes from sincere conviction. We must first be convinced before we attempt to convince others." And going back to the beginning of recorded history, Aristotle professed that above all traits a public speaker should possess—intelligence, humor, appearance, self-control, balance on the issues—the most important trait was respect and trust of the speaker. The foundation for an indestructible podium is **integrity.**

Credibility is established in your opening:

Your opening is your best opportunity to prove your sincerity. It should go without saying that your revealing, personal story also will be the device that establishes your sincerity with the audience. If you use a true story about yourself, who can doubt it? What if you cannot think of a revealing personal story? Then try to weave some explanation of your credentials or experience into your opening. Be very careful not to go on too long about your background to avoid appearing pompous and conceited. An audience uses the first few minutes of your speech to judge how sincere and credible you are and to decide whether they want to hear what follows. I cannot overemphasize the importance of the first part of

your speech and sticking to statements that are clearly verifiable. It also is helpful if you can connect yourself with someone on the dais or in the audience who is respected by your listeners. Again, such identification must be sincere.

When sincerity is needed most: At some point in most people's lives, they will be called upon to deliver bad news to an audience. Never is there a greater need for sincerity and credibility than when you have to tell someone that something important to them has gone terribly wrong. Probably no one was better at this than Franklin D. Roosevelt. Few public speakers have had to deliver the kind of speech that included the unforgettable line, ". . . we have nothing to fear but fear itself." If you study his delivery, he does not avoid the truth or beat around it; he establishes his sincerity by acknowledging the problem or bad news and then leads the audience to his interpretation of how that bad news can and will build to a better future (or a call for positive action). If you are faced with what you consider a daunting task, think of an arrow shot in the air. Aim for the truth, loft it high with sincere intentions and lubricate the shaft with positive reinforcement. If targeted appropriately, not only will it hit the bull's-eye, but it will be the most memorable speech you will ever deliver.

E. Advice on Delivering Your Speech: Rehearse-Rehearse-Rehearse!

The first and most important part of delivering a good speech is to rehearse it as many times as you can, in the most realistic setting possible. If you practice your speech enough times before delivering it, you should avoid any problems with stage fright.

HINT: Rehearsing is not complete if you are only doing it in front of a mirror. You should do whatever you can to rehearse in front of other people—your friends, spouse, your kids—anyone who will not be afraid to give you honest feedback. You can only get a true sense of your timing if you rehearse in front of people because when practicing alone, a person invariably speaks more quickly. Also, if your speech includes humor or jokes, do not—ever—rely only on your own sense of humor. Jokes must be tested on third parties BEFORE you make them part of your public speech.

Memorization: If you haven't yet memorized your opening, stop reading now and start memorizing. If at all possible, memorize different lengths of openings. Depending on your agenda and the type of venue, you might find that you are short of time or need to fill more time. When speaking to large groups where I'm not the only speaker, I try to memorize 30-second, 60-second and 90-second openings. I don't decide which to

deliver until after I've been introduced. It's well worth the time it takes to memorize. There is a short "cheat" which you can use when memorizing your opening. I always have my 30-second opening memorized, but if I want to go to 60 seconds, I have a couple of letters (or words) on the top of my outline which signify the first letters (or words) of important memory cues of the longer opening. If I'm going to the 90-second opening, on the other side of the outline I'll have three to five letters (or words) that signify points to cover in my longer version.

F. A Few Last Helpful Tips

Microphone Failure? Use it as an opportunity to connect with your audience and make humorous acknowledgement about infallible electronics—then start conversing with those in the back of the room.

Heckler? Don't acknowledge a heckler initially. If it continues, look at the audience in silence to see if they are sympathizing with you. Do not validate the heckler's comments by responding because that's what he or she wants. If it still continues and is too disrupting, step back and stop speaking until the heckler is removed from the room.

Blunder? Don't draw attention to it; just continue and correct it. If the blunder is glaring, take a clear look at the audience while SMEATHING.

Run Out of Time? Do NOT acknowledge that you are out of time, which is a very common blunder. Just finish up by moving to your conclusion.

Prior Speaker Took Too Much of Your Time? Don't blame anyone; the audience already knows it. Just go to your conclusion.

Prior Speaker Covered Your Points? Don't repeat or reiterate these points with your particular spin. Cut your speech. Remember: Less is More!

Interrupted by Applause? Ha! This is not a "problem"– this is called a "blessing." If sustained applause is making your speech go long, mouth the words "thank you" to the audience . . . and shorten your speech!

Someone Asks a Question You Can't Answer? Admit you don't have the answer on the tip of your tongue and compliment the questioner. Ask him or her to see you personally after your speech to discuss it further.

Congratulations!

You've done it! You know what to do in the ten crucial minutes leading up to your speech and what to do in the days prior. You have all the tools you need to deliver an organized and successful speech.

In getting to know your audience, you have found the way to connect with them by revealing part of yourself. By bringing all these elements together, you will not only deliver your primary message, but a memorable speech, as well.

Now, go out there and speak with confidence.

REFERENCES AND BOOKS FOR FURTHER READING

Ashton Applewhite, William R. Evans III and Andrew Frothingham have compiled an excellent resource guide for all public speakers:
And I Quote: The Definitive Collection of Quotes, Sayings, and Jokes for the Contemporary Speechmaker
(Published by Thomas Dunne Books, Revised and Updated edition; March, 2003)

Dale Carnegie was a great motivational speaker. Although his books contain a few dated illustrations, I think **The Quick and Easy Way to Effective Speaking—Modern Techniques for Dynamic Communication** is essential reading for anyone who wants to be a good public speaker.
(Published by Pocket Books, Reissue edition; March, 1990)

James C. Humes has written a few books about public speaking. One of his best is **Speak Like Churchill, Stand Like Lincoln: 21 Powerful Secrets of History's Great Speakers.** His historical examples are not only riveting, but also humorous.
(Published by Three Rivers Press; April, 2002)

Susan Jones is a renowned speechwriter. Her book,
**Speechmaking: The Essential Guide to Public
Speaking,** is one of the most thorough books on
the art and science of writing a good speech.
(Published by Politico's Publishing; November, 2004)

Abraham H. Maslow was a psychologist renowned
for his theory of "hierarchy of human needs."
Although he is not famous for speechmaking, his
humanistic theories are useful in trying to understand
people and the behaviors of an audience. Use the
internet to find his various publications.

Laurie Rozakis provides a lot of basic information on
public speaking in her book, **The Complete Idiot's
Guide to Public Speaking.**
(Published by Alpha Books; June, 1999)

www.scopesys.com/today is a website where you
can research all the significant events happening each
and every day of the year. This is helpful if you are
trying to bring some topicality to your speech.

Toastmasters International is an organization
composed of a worldwide network of "clubs"
devoted to creating unlimited opportunities for
speakers to practice in public. Also, their website,
www.toastmasters.org, provides informative
references for learning about public speaking.

Jerry Weissman has written a book about giving presentations, **Presenting to Win: The Art of Telling Your Story.** It provides one of the best guides on power-point presentations and how to use graphs, charts and visual aids properly during a speech. *(Published by Financial Times Press; March, 2003)*

About the author

Vance Van Petten is the Executive Director of the Producers Guild of America, the preeminent organization representing producers of motion pictures and programming for television and new media. Under Van Petten's stewardship since January of 2000, the Guild's membership has grown from 350 to over 3,500 members, with a prestigious Board of Directors led by President Marshall Herskovitz.

Prior to joining the PGA, Van Petten was Executive Vice President of Business and Legal Affairs at Studios USA/Universal Television, where he oversaw all television production and distribution, including the *Law & Order* franchise. He was previously Twentieth/Fox Television's Executive Vice President, Business and Legal Affairs, where he oversaw reality television production and distribution for such series as *America's Most Wanted* and *Cops*. During his tenure at Fox, he was in charge of business affairs for the successful launch of the FX Network. From 1984-1992, Van Petten was Senior Vice President of Business and Legal Affairs at Paramount Domestic Television, where he was in charge of syndicated series, such as *Entertainment Tonight* and *The Arsenio Hall Show*. Prior to Paramount, Van Petten was a partner in the entertainment law firm of Irwin and Rowan where he represented actors, producers,

writers, production companies and comedy groups such as Second City and The Groundlings.

In 1978, Van Petten simultaneously received two postgraduate degrees from the University of Southern California, a juris doctorate and a master of public administration. He received his Bachelors of Arts degree from the University of California, Los Angeles, in 1975, with Phi Beta Kappa distinction. During the past several years, Van Petten has had speaking engagements for many influential organizations, such as the L.A. County Bar Association, UCLA, USC and Whittier Law Schools, Columbia College–Chicago, Women in Film and NATPE. He lives in Los Angeles with his wife and family.

Other books in the
10 Minutes 2 Success series:

Ten Minutes to the Audition
by Janice Lynde

Ten Minutes to the Pitch
by Chris Abbott

For more information,
visit: www.Tallfellow.com

Tallfellow®Press
Los Angeles